Copyright © Richard Johnson

In no way is it legal to reproduce, duplicate, or transmit any part of this document in either electronic means or in printed format. Copying this publication is strictly prohibited and any replication of this document is not allowed unless with written permission from the publisher. All rights reserved.

RICHARD JOHNSON

EAT shit

SHITBAG

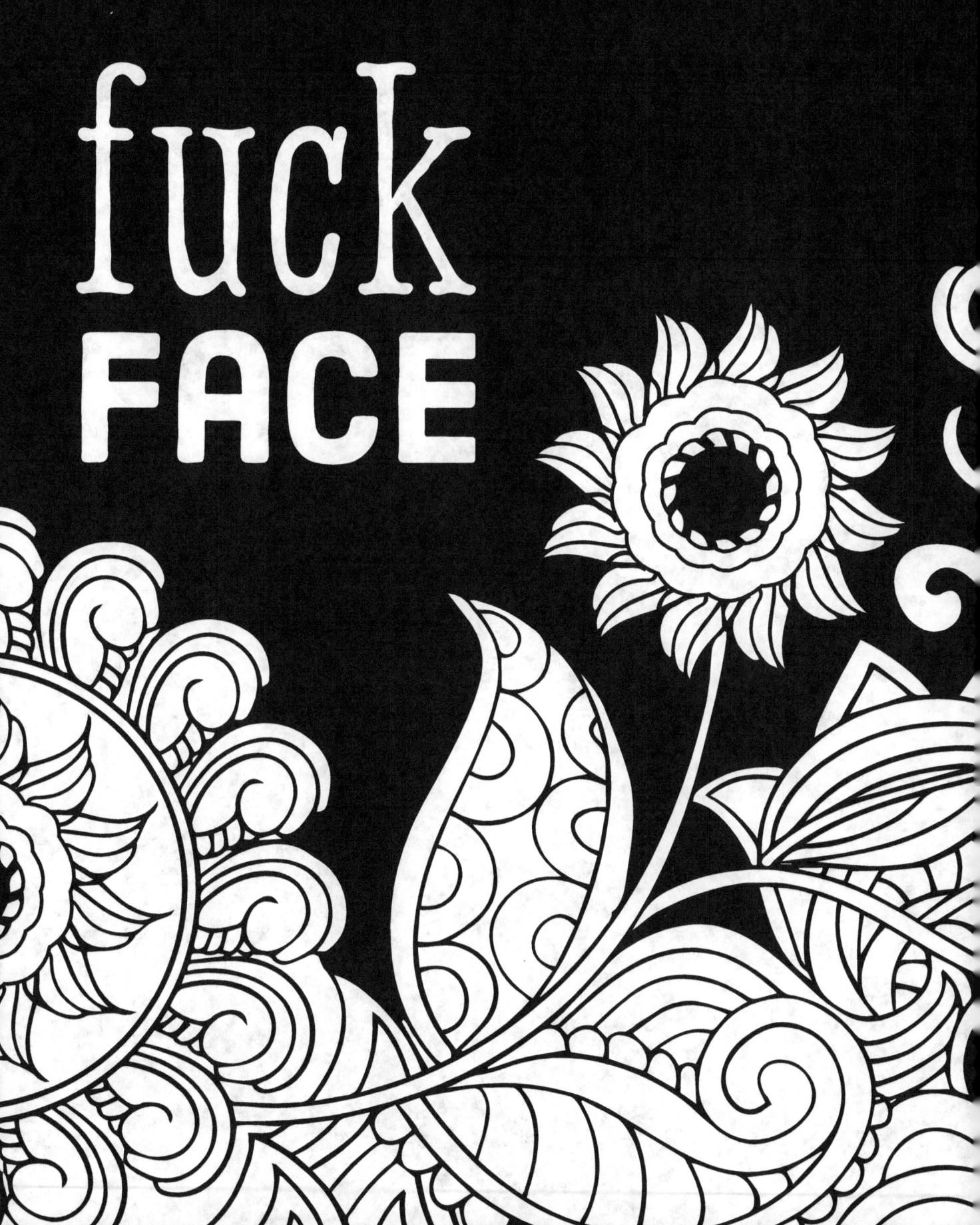

blow it OUT YOUR ass

fucking motherfucker

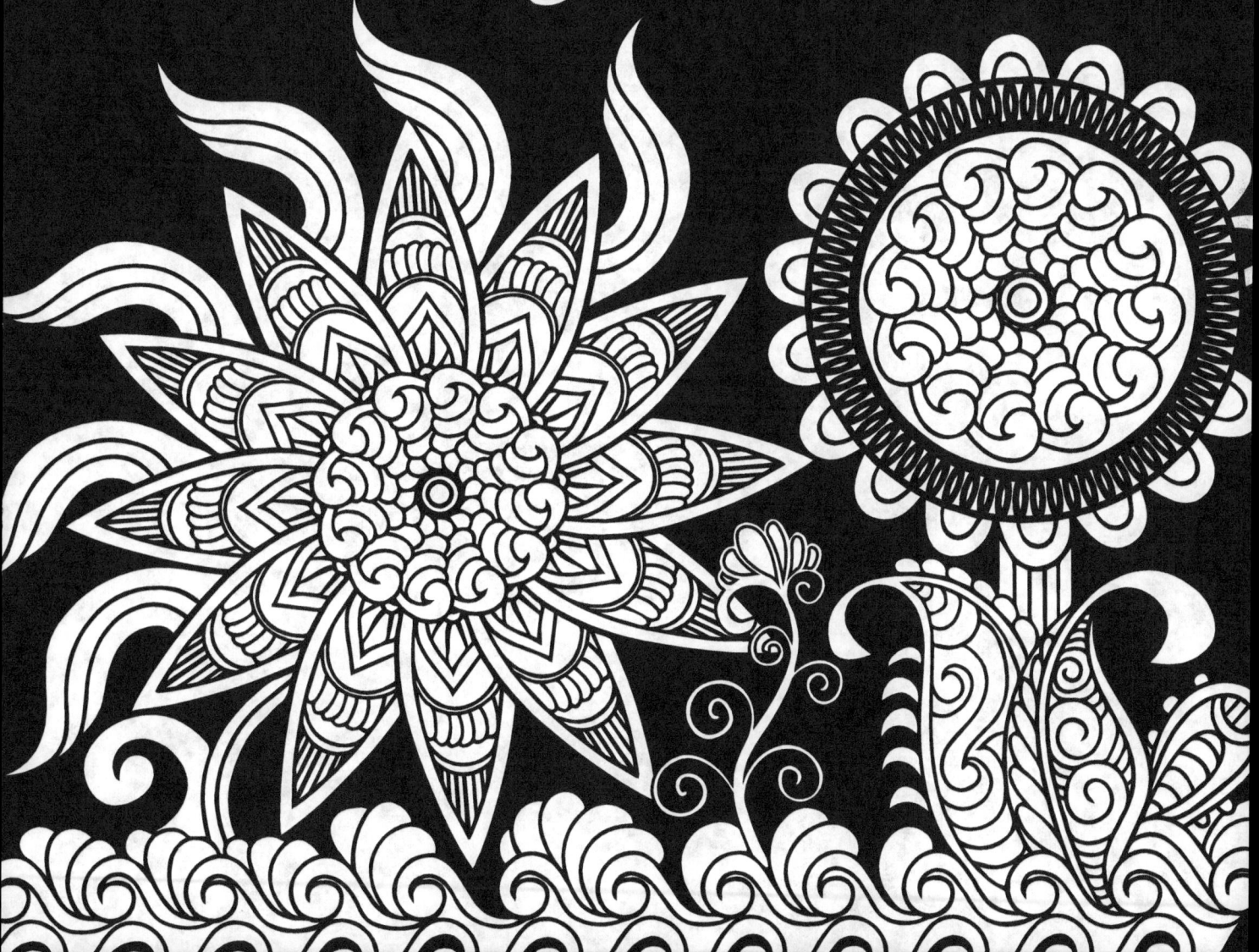

PIECE OF *shit*

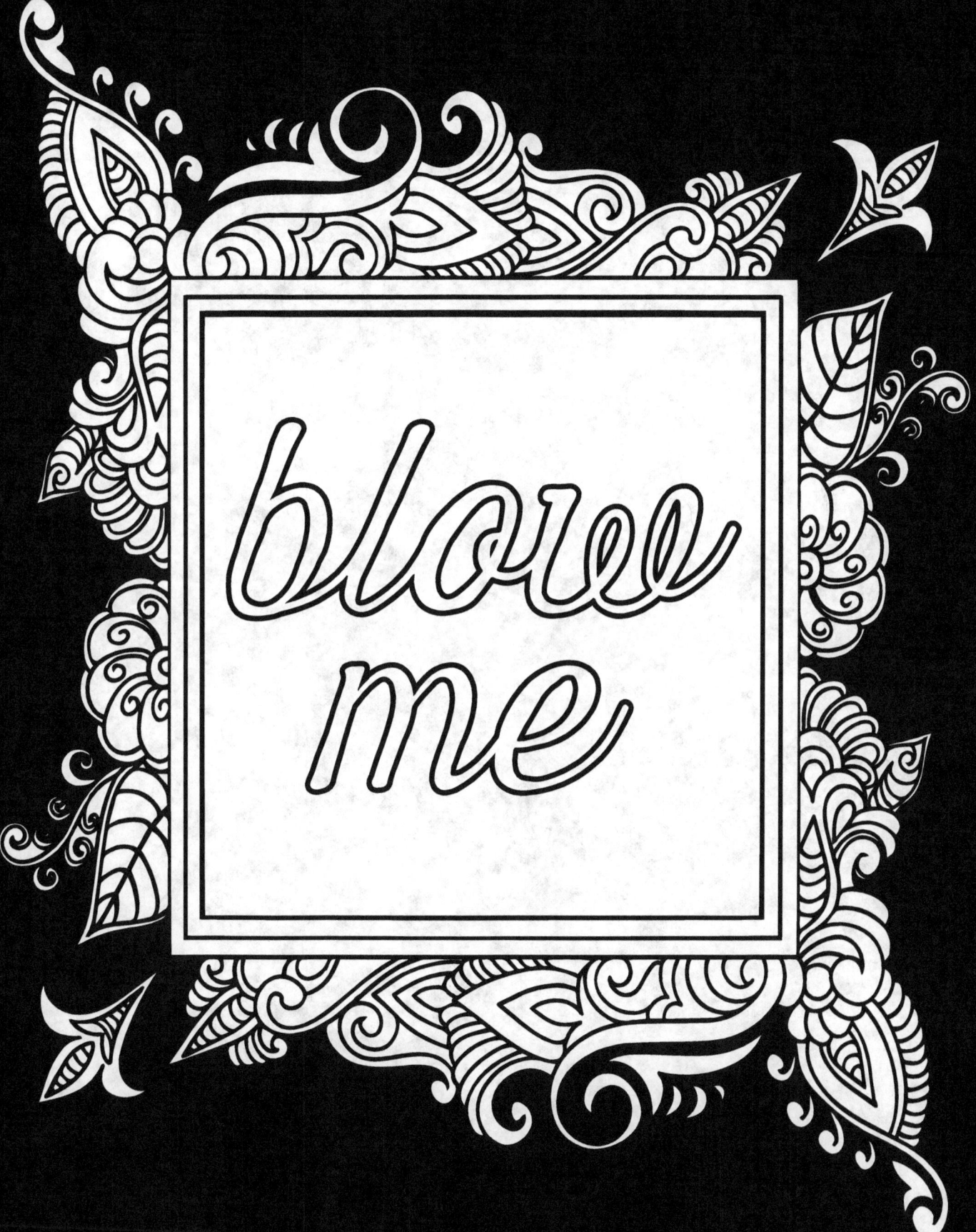

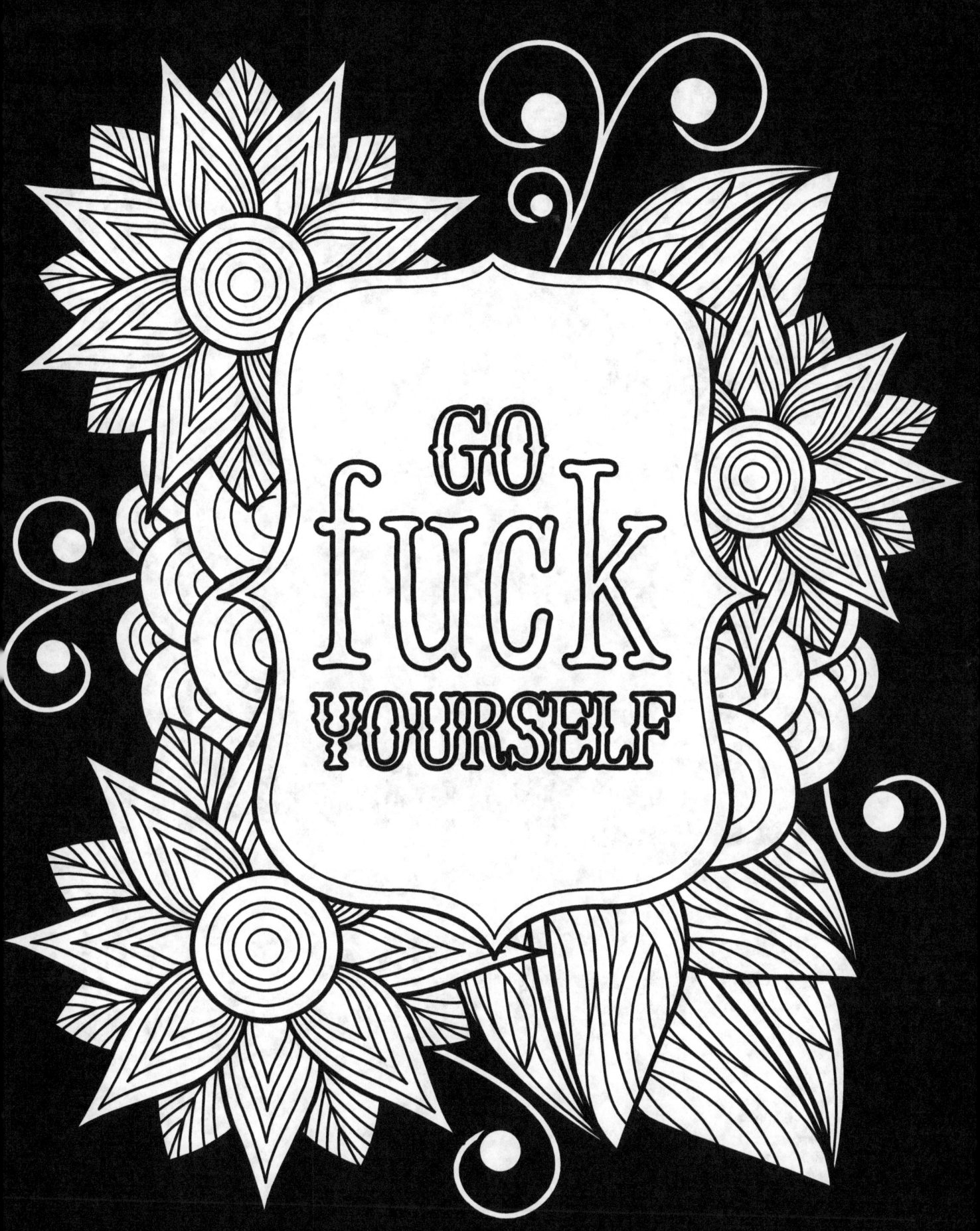

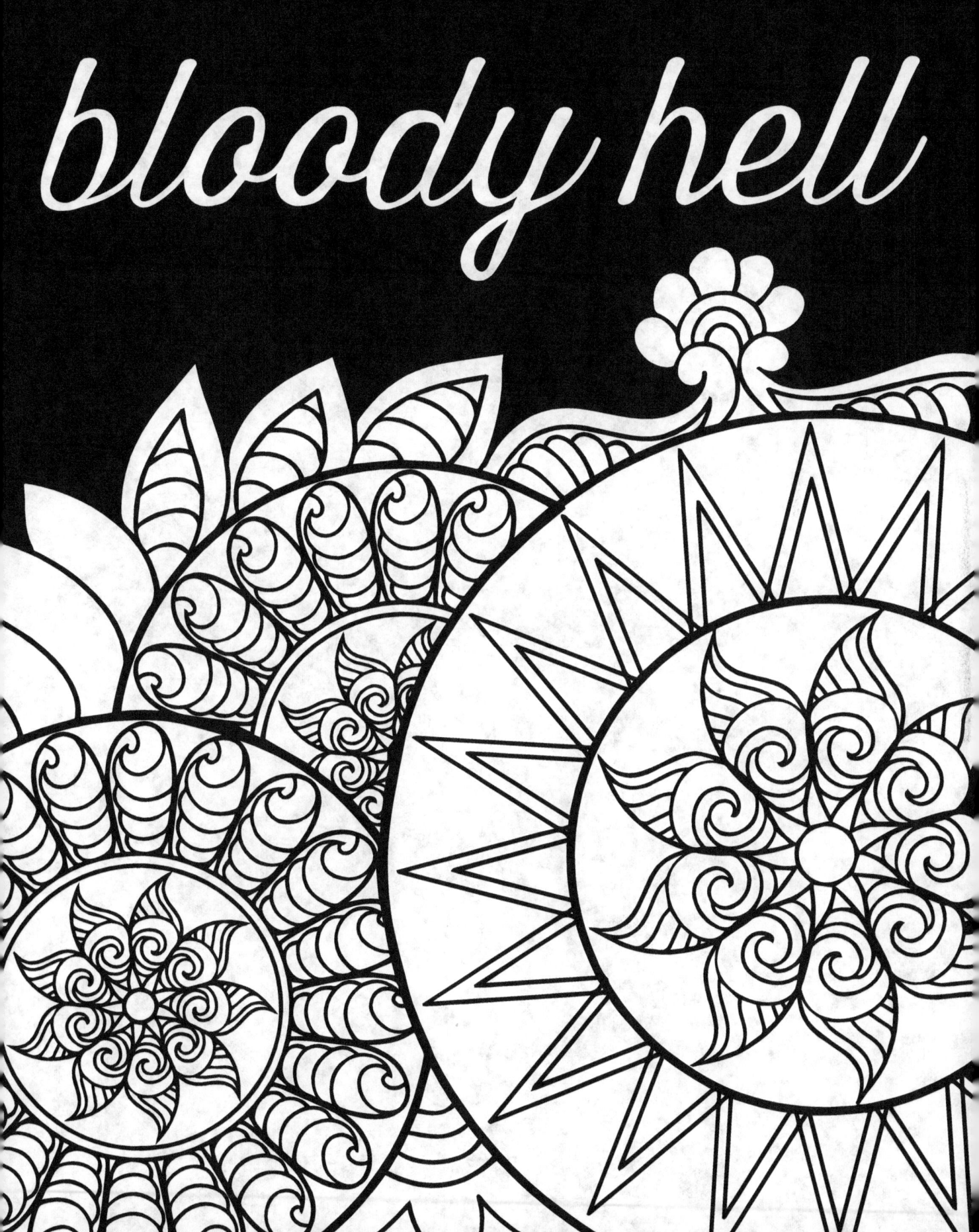

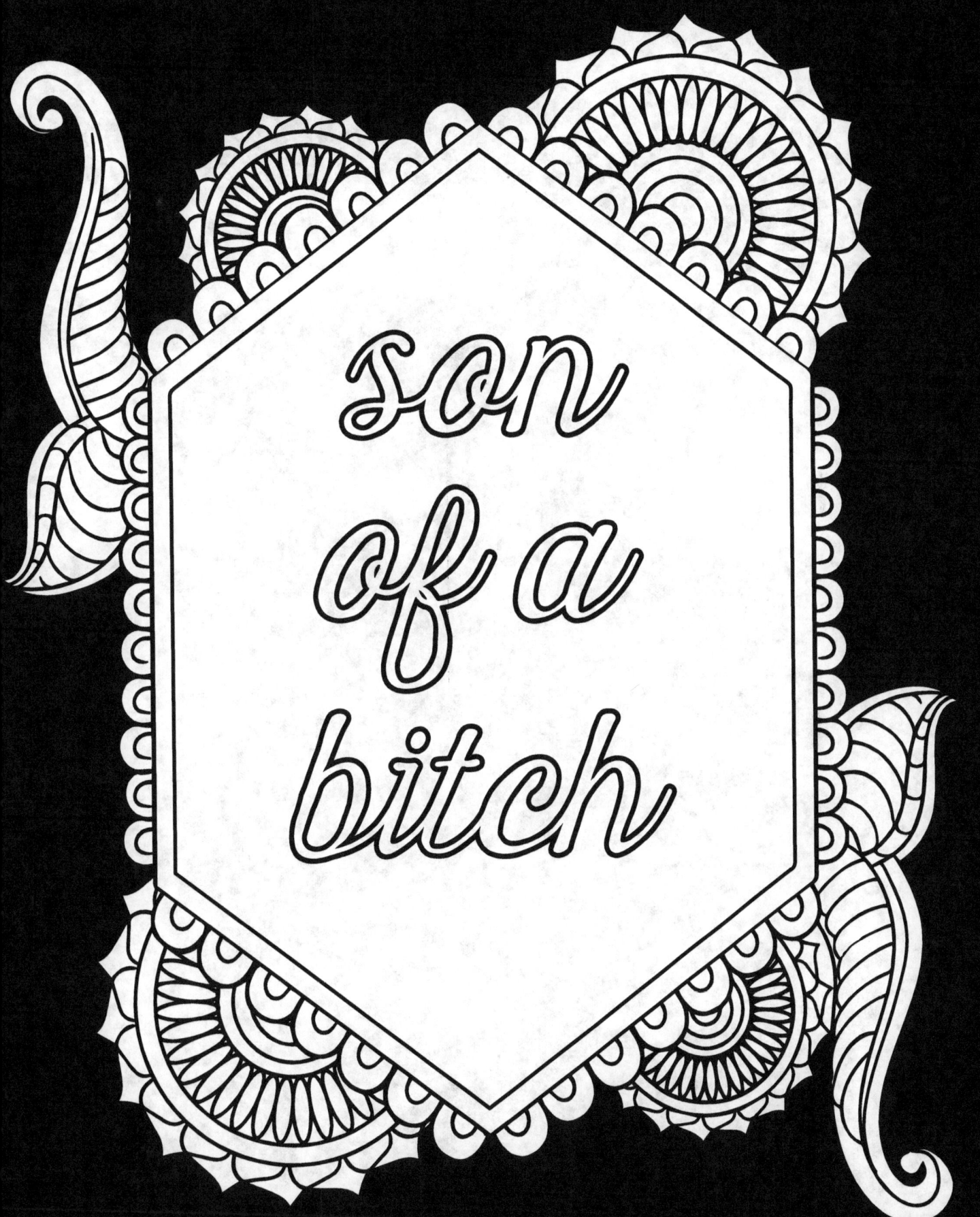

balls

FANNY flaps

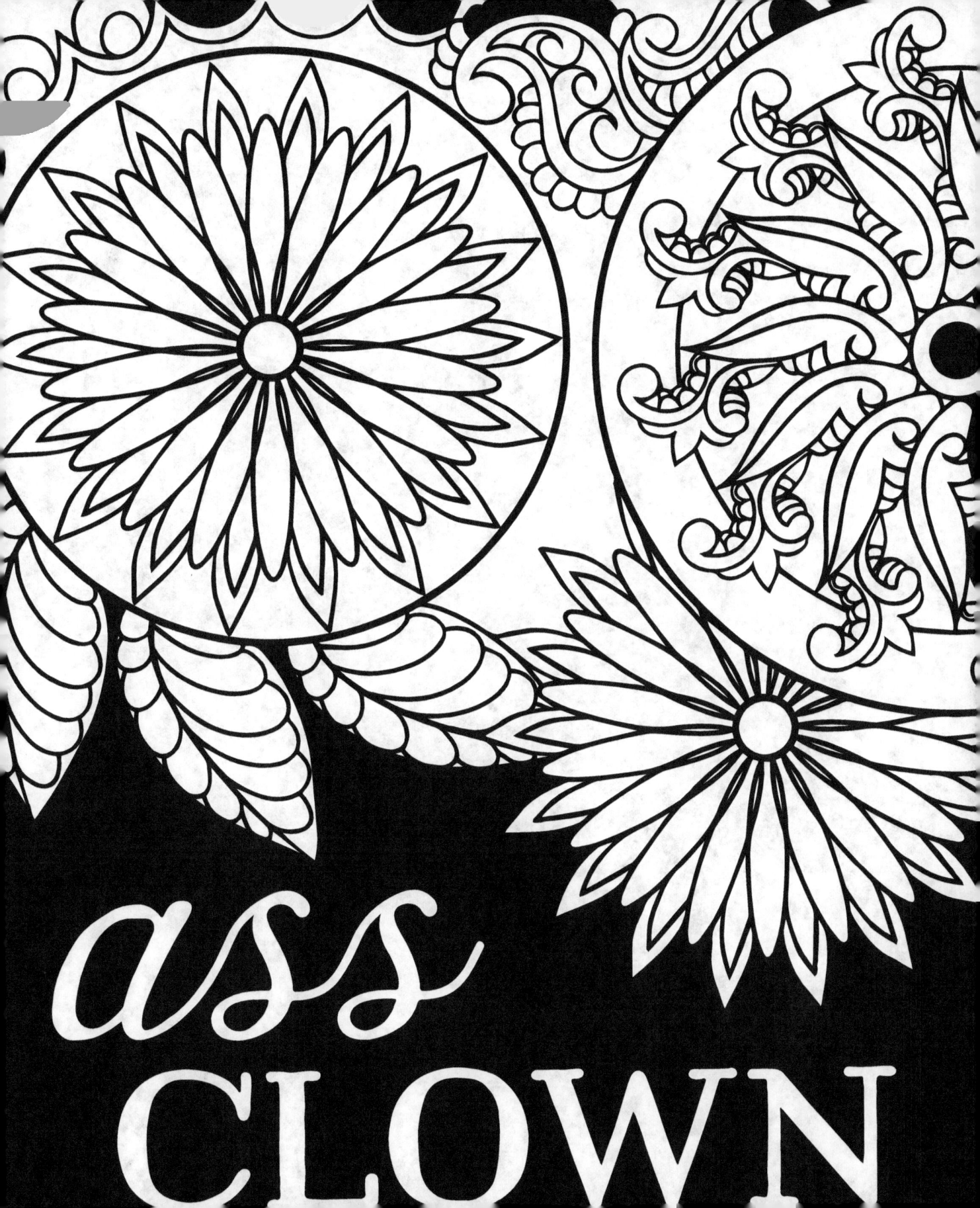

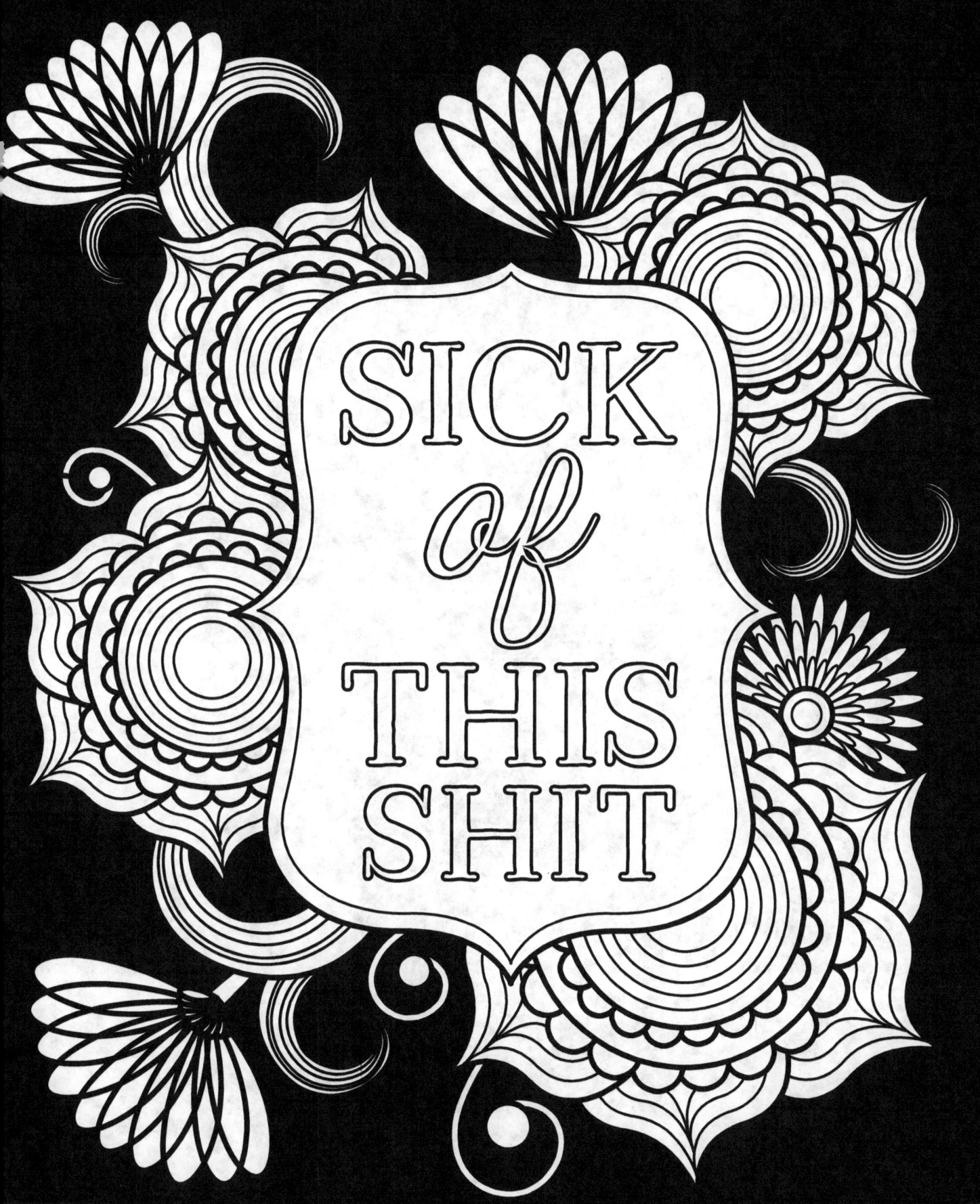

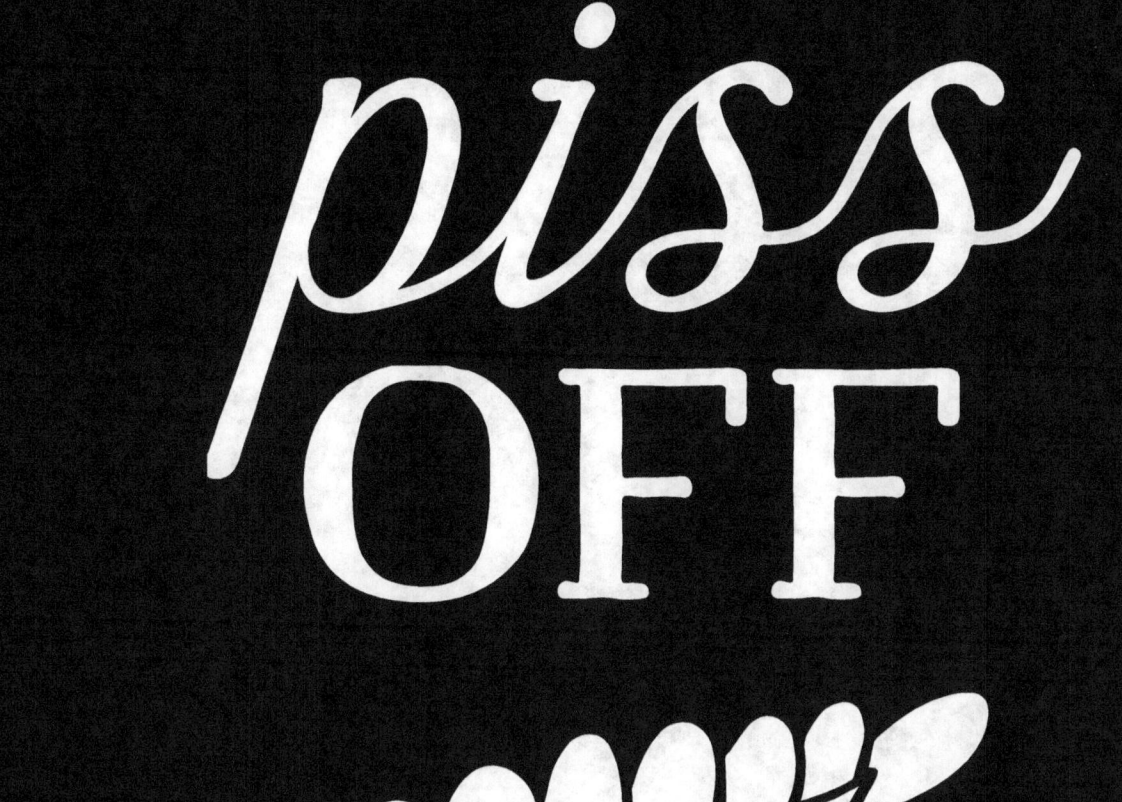

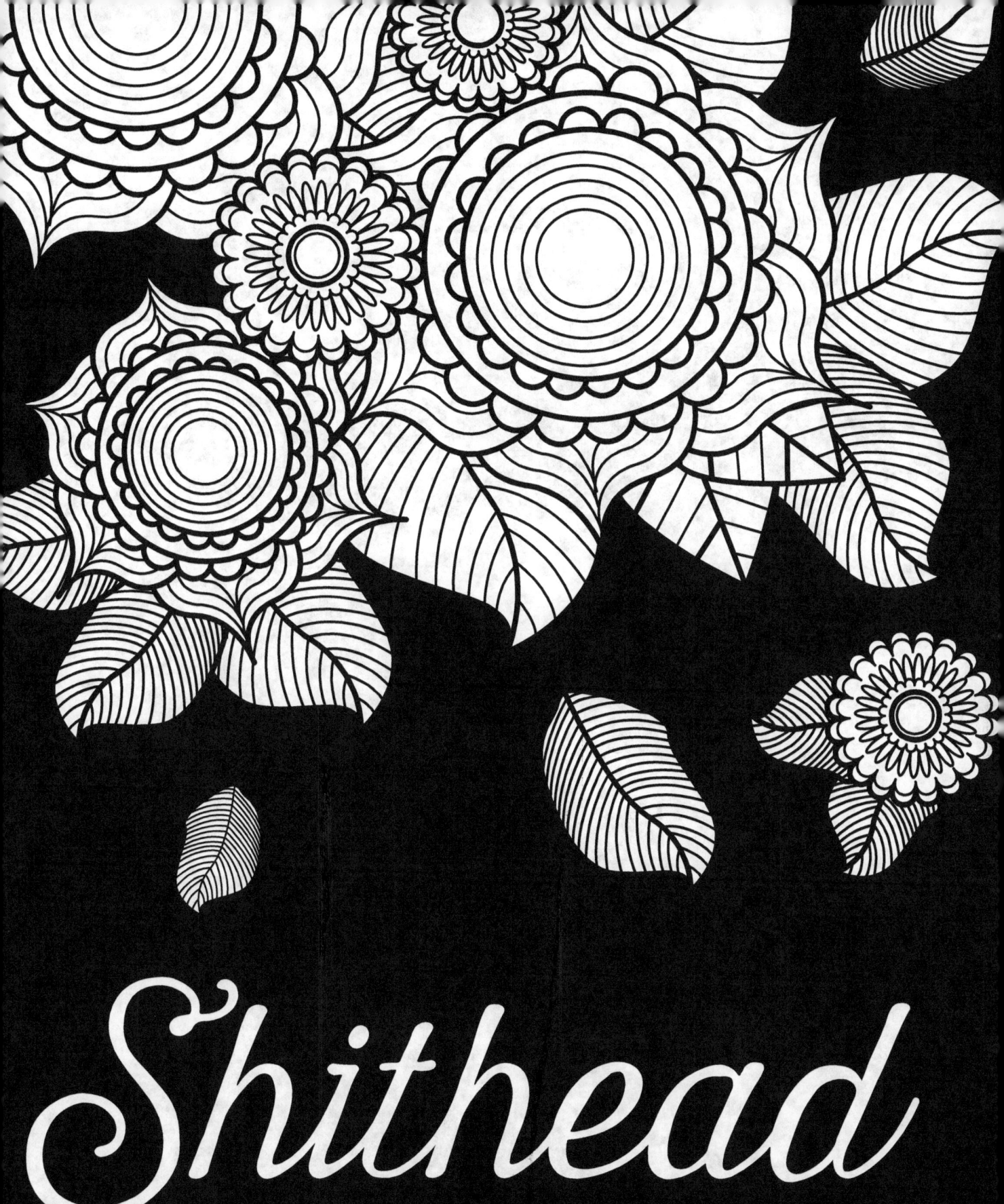

butt
SNIFFER

DOUCHEBAG

bastard

TURD
nugget

FUCK CRUMPET

www.ingramcontent.com/pod-product-compliance
Lightning Source LLC
Chambersburg PA
CBHW081120180526
45170CB00008B/2938